The Metropolitan Museum of Art
Director's Tour
A WALKING GUIDE

Thomas P. Campbell

The Metropolitan Museum of Art, New York
In association with Scala Arts Publishers, Inc.

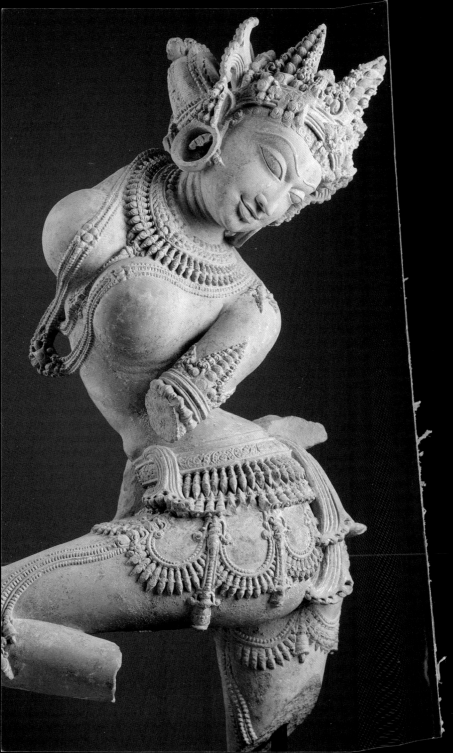

Introduction

This walking guide is my attempt to take you on the tour I would give if I were at your side, focusing on both the stories of the Met and some of its greatest masterpieces. Of course, there is no single path through such a vast museum; my attempt here is to be comprehensive as well as mindful of the constraints of time and efficient navigation. (If your time today is limited, you may want to use the list of Visitors' Favorites in the back of this book to explore the Museum; see pp. 88–93.)

My tour will take you through the first and second floors of the Museum separately, crossing geographic and historical boundaries as it goes. There will be surprising connections among the works of art, in both form and content. Some of these I have pointed out in the text, but others will no doubt occur to you along the way. That is the delight of a truly global museum: the unexpected encounters that deliver a fresh perspective, or a jolt of inspiration, or simply a moment of solace.

It is my hope that this will be just one of many visits you make to the Met. The extent of your curiosity will be the measure of my success.

Thomas P. Campbell
Director

Note: It is possible that one or more works pictured in this guide will not be on view, as the Metropolitan Museum contributes to many international exhibitions. Occasional changes in individual galleries and shifts within the Museum are also to be expected.

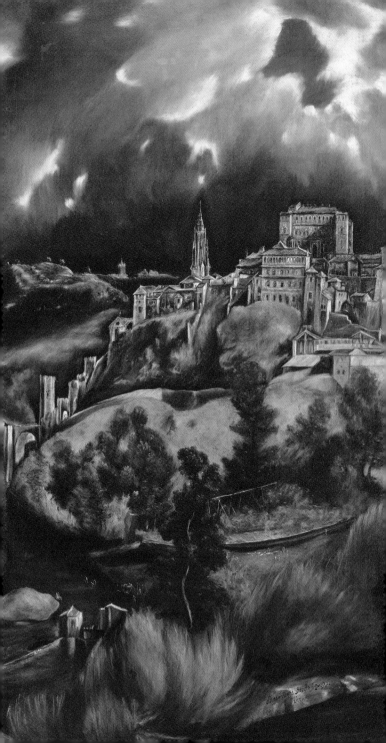

Visit One: First Floor

The American Wing

Arms and Armor

Robert Lehman Collection

Medieval Art

European Sculpture and Decorative Arts

Modern and Contemporary Art

Arts of Africa, Oceania, and the Americas

Egyptian Art

The Great Hall

Greek and Roman Art

VISIT BEGINS IN GALLERY 100

Main Entrance at 82nd Street

First Floor

GALLERIES 100–958

The Museum has seventeen curatorial departments. On this first itinerary, we will visit the galleries devoted to nine of them:

- Egyptian Art
- The American Wing
- Arms and Armor
- European Sculpture and Decorative Arts
- Medieval Art
- Robert Lehman Collection
- Modern and Contemporary Art
- Arts of Africa, Oceania, and the Americas
- Greek and Roman Art

We will begin in the 3rd millennium B.C., in Old Kingdom Egypt, but we will not continue in chronological order. Following the most efficient path through the Met means traversing history and jumping geographically across the globe. Such is the charm of a building that has been built up over nearly a century and a half and of a collection that spans more than five thousand years.

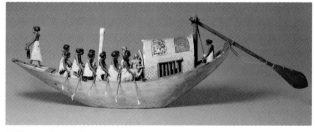

Gallery 105 (page 10)

Tomb of Perneb, ca. 2381–2323 B.C.

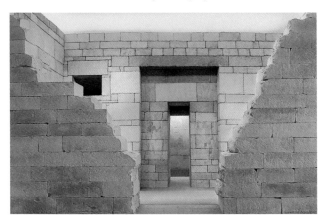

The people of ancient Egypt had a complex view of the afterlife. Much of the great art and architecture they produced reflected their belief that the soul outlived the body and required various types of sustenance and protection—including shelter, in the form of a tomb. This 4,500-year-old limestone structure from the Saqqara cemetery in Lower (northern) Egypt is the tomb of a high official named Perneb. The body was buried underground and was inaccessible after the funeral, but relatives and priests would have entered this aboveground structure to make offerings and recitations on behalf of the deceased. The large doorway is flanked by two depictions of the tomb's owner. In the dense decoration on the inner walls, cattle are shown being slaughtered, and offering bearers bring food and drink. These images were thought to magically supply the deceased with everlasting provisions.

Lila Acheson Wallace Galleries of Egyptian Art

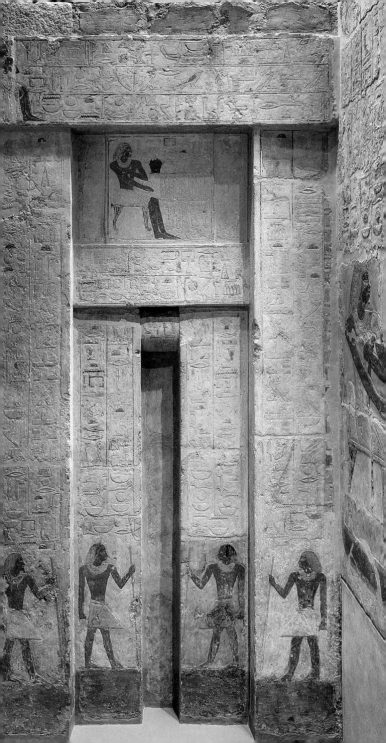

Models from the Tomb of Meketre, ca. 1981–1975 B.C.

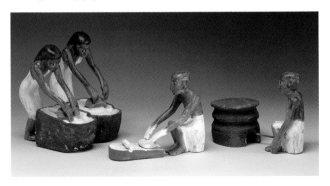

The Met has been involved in archaeological work in Egypt for over a century. From 1906 to 1936 the Museum was permitted to excavate at ancient sites and split the finds with the Egyptian government. Egypt had first choice of objects and kept half for its own museums, but the balance became part of the Met's collection, including these models from the tomb of the high official Meketre. Today, the Museum still conducts excavations for research purposes, but all finds remain in Egypt.

In March 1920, when the Met's archaeologists were clearing out Meketre's tomb, they discovered a small lower chamber that had been left untouched for about four thousand years. Inside, in the words of Herbert Winlock, the expedition's leader, were "myriads of little brightly painted statuettes of men and animals and models of boats"—part of Meketre's funerary equipment, intended to furnish his material needs in the afterlife. Among the scenes are a busy brewery and bakery where the hands of the bakers are painted white, as if dusted with flour. Thanks to such extraordinary details, the set of models functions, on one level, like a time capsule, providing unsurpassed insight into the routines and rhythms of daily life in ancient Egypt.

Lila Acheson Wallace Galleries of Egyptian Art

The Temple of Dendur, ca. 15 B.C.

1

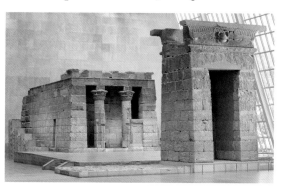

This temple to the goddess Isis once stood on a bank of the Nile River in Nubia, a region in the very south of Egypt. When the Egyptian government decided to build a new dam at Aswan in the 1950s, flooding threatened a number of ancient sites, and the United States helped in the rescue effort. Egypt presented this building to the American people as a thank-you gift. It was dismantled, block by sandstone block, in 1963 and shipped in 661 crates to New York, where it was reassembled and unveiled to the public in 1978.

The temple walls are decorated with reliefs showing the pharaoh making offerings to deities. (The pharaoh here is actually the Roman emperor Augustus, because, at the time, roughly two thousand years ago, Egypt was part of the Roman Empire.) Originally, these carved images were probably brightly painted, but time and rising waters caused the pigments to wear off; the uniform color of this and other surviving Egyptian temples, like the pure white marble of ancient Greek and Roman statuary, is thus completely misleading. Another alteration in the temple's appearance was made by 19th-century European visitors to Dendur who carved their names into the stone; look for this historic graffiti just after you pass through the columns, to the left.

The Temple of Dendur in The Sackler Wing

John Vanderlyn (American, 1775–1852)

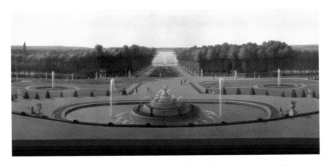

Panoramic View of the Palace and Gardens of Versailles, 1818–19 (detail)

This work is a rare survivor of a form of public art and entertainment that flourished in the 19th century. Invented in Great Britain in the 1780s, panoramas were displayed in the darkened interiors of cylindrical buildings, or rotundas. Illuminated by concealed skylights, the circular paintings offered the illusion of an actual landscape surrounding the viewer. Visitors paid a small admission fee and were rewarded with vicarious travel to a distant part of the world. The Metropolitan is unique among art museums in displaying such a large-scale landscape painting in the round.

A native of Kingston, New York, John Vanderlyn chose the subject of Versailles for his panorama, hoping to introduce Americans to the splendors of French culture. He arranged with the City of New York for a nine-year lease of land behind City Hall—at a "peppercorn" rent—on which to build his rotunda. Unveiled to the public on June 29, 1819, the enterprise was less profitable than he had hoped (in hindsight, he acknowledged that an American subject might have been more popular). By August of that year, Vanderlyn was broke.

The Lawrence A. and Barbara Fleischman Gallery

The Charles Engelhard Court

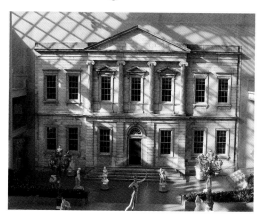

Martin E. Thompson, Branch Bank of the United States, 1822–24

The Met was conceived as an encyclopedic museum, but its founders focused on acquiring European works. The Museum's first venture into American art came in 1909, with an exhibition of furniture, silver, and other decorative arts celebrating the 300th anniversary of Henry Hudson's voyage up the river that now carries his name. The public responded enthusiastically, and in 1924 the Museum opened an entire wing for American art. The wing is now anchored by the Charles Engelhard Court (1980), one of New York's great public spaces. At either end of the court are portions of historic buildings: you may have just walked through one of them, the facade of a federal bank once located on Wall Street, in Lower Manhattan. Its references to ancient Greek architecture, including four Ionic columns, helped to project a sense of seriousness and security. Opposite is an architectural element of a very different character, from Laurelton Hall, Louis Comfort Tiffany's home in Long Island. The loggia (overleaf), or porch, resembles a design from 17th-century India, and the column capitals were inspired by nature—there are buds, blooms, and seedpods of four different types of flower.

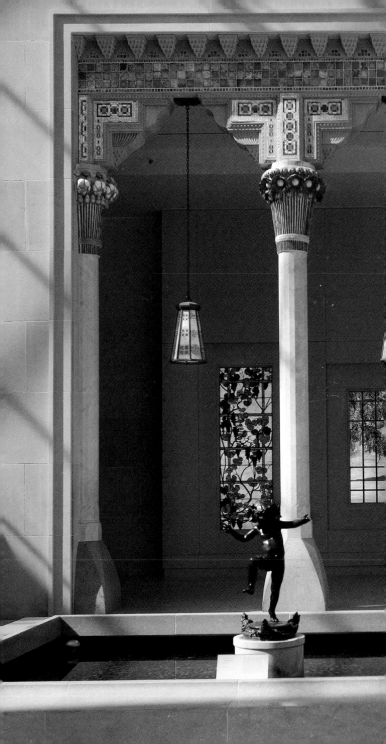

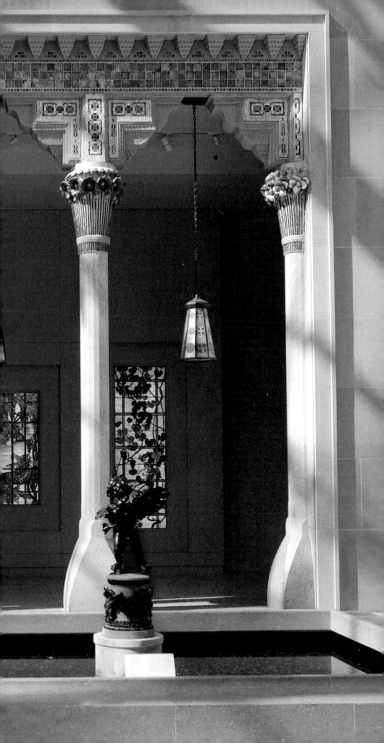

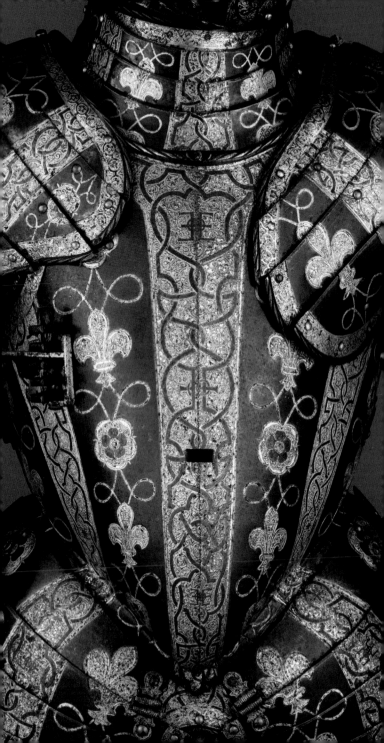

Armor of George Clifford, ca. 1585

For many centuries, elaborate arms and armor were among the essential trappings of rulers and other people of high rank in many parts of the world. This ensemble was made in the 1580s by the English royal workshop at Greenwich. Forging steel in itself requires considerable skill, but in this case, the armorers did much more: they heated the metal to an extremely high temperature to give it a bluish color, then embellished every surface with delicate etched patterns and mercury gilding (a very thin layer of gold). The stylized roses, fleurs-de-lis, and letter *E*s in a back-to-back design (see the kneecaps) all refer to Queen Elizabeth I and her dynasty, the Tudors. In 1590 the wearer of the armor, George Clifford, Earl of Cumberland, was appointed Queen's Champion, meaning that he competed on her behalf, defending her honor in the spectacular mock battles known as tournaments. The masterly execution of the armor reflects the splendor of the queen herself.

The Metropolitan is one of the only art museums in the world with an important collection of arms and armor, allowing our visitors the unique opportunity to appreciate this material as an art form.

Emma and Georgina Bloomberg Arms and Armor Court

Armor (*Yoroi*), early 14th century

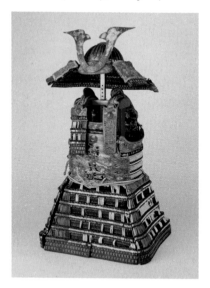

Unlike late medieval and early Renaissance European armor,
which was made of shaped steel plates, most Japanese armor
of those periods was composed of hundreds of small iron and
leather plates coated with lacquer and joined by silk laces in
rainbow colors, which were symbolic of both good fortune
and fleeting beauty. This *yoroi*, an early form of cavalry armor
worn by high-ranking samurai in the 13th and 14th centuries,
is the only example of its kind in an American collection. The
leather covering the breastplate is stenciled with the image of
the Buddhist deity Fudō Myō-ō, whose fierce expression, inner
strength, and calmness were prized by samurai. The helmet
(*kabuto*) was made slightly later than the armor. Its striking
sculptural form and widely flaring neck guard would have pro-
tected the wearer from swords, spears, and arrows. For many
centuries, this armor was preserved as a votive offering in a
shrine, where it is believed to have been placed by the legendary
14th-century shogun Ashikaga Takauji.

Studiolo from the Ducal Palace at Gubbio, ca. 1478–82

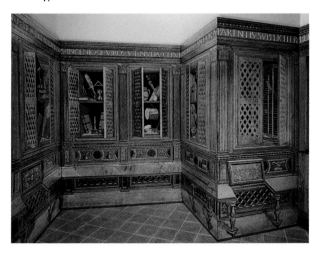

Throughout history, artists have delighted in imitating nature and fooling the eye. The impulse ran particularly strong in Renaissance Italy. At first glance, this tiny room looks like a fully outfitted interior, with benches set against the lower walls and cabinets above. Many of the elements even cast shadows. But it is all an illusion—the entire decoration was executed in intarsia, an elaborate technique in which thousands of pieces of wood of different types and colors are fitted together to form an extraordinary result. The room was Federico da Montefeltro's private retreat, or *studiolo*, in his palace in Gubbio, Italy. Federico was a great military leader, and there are references to military glory here, such as the helmet crowned with an eagle in the back right corner. But most of the decoration alludes to peaceful pursuits: the latticed cupboards contain musical instruments, books, scientific equipment, and a bird in a cage. Here, Federico could display and indulge his love of learning, especially for the literature and history of ancient Greece and Rome.

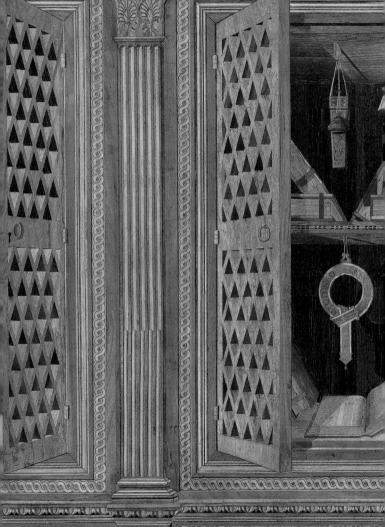

Plate with the Battle of David and Goliath, 629–30

The great financier J. P. Morgan, a Trustee and President of the Museum, gave the Met thousands of works of art—the outcome of his voracious collecting style. Among them were six silver plates discovered in northern Cyprus, of which this is the largest. The plates were originally part of a set of at least nine that tell the Old Testament story of King David's early life, including his defeat of Goliath, the giant Philistine. Their extremely fine quality, and stamps on the silver, point to production in the palace workshops of Constantinople, capital of the Byzantine Empire, in the year 629 or 630. Each plate would have begun as a single cast-silver ingot, hammered out into a circular shape. Silversmiths would have used hammers to raise the rough forms from the background, then chisels to shape the bodies and costumes. Fine details, such as locks of hair and flowers on the battlefield, were created by punching, engraving, and chasing. It is simply astonishing not only that a work of such refinement was produced nearly 1,400 years ago but also that it survived the intervening centuries in impeccable condition.

To reach the next stop, pass through the opening in the wall behind you. This intimate space under the Grand Staircase, known as the Crypt Gallery (302), exhibits works from Byzantine Egypt.

Mary and Michael Jaharis Galleries

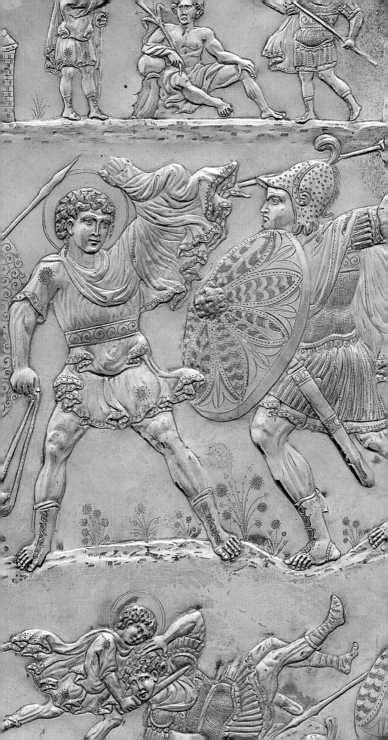

Antico (Italian, ca. 1460–1528)

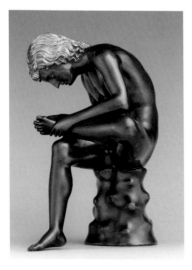

Spinario (Boy Pulling a Thorn from His Foot), probably modeled by 1496, cast ca. 1501

Antico, the nickname of Pier Jacopo Alari Bonacolsi, refers to his lifelong project of revitalizing the sculpture of antiquity. The Mantuan artist is known above all for bronze statuettes of exquisite detail and refinement that reproduce famous classical compositions. This statuette of a boy sitting on a tree stump as he extracts a thorn from the sole of his left foot is a smaller version of the celebrated Hellenistic *Spinario* in the Capitoline Museums, Rome. The original is not terribly large—under two and a half feet—but Antico's version is tiny, not even eight inches tall. Yet it has a presence, a potency, that fills the gallery. This effect may be due to the boy's intense concentration, combined with the visual impact of his bright gold hair and silver eyes against the warm, smooth bronze. From his vantage point in the thick of the Italian Renaissance, when knowledge of ancient Greek art and philosophy fostered a new world view with man at its center, Antico was able to imbue his sculpture with an energy and psychological penetration unmatched even by the original.

Scenes from the Legend of Saint Vincent of Saragossa and the History of His Relics, ca. 1245–47

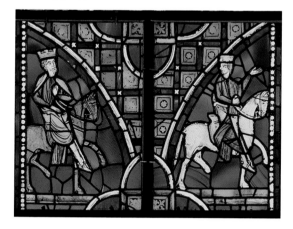

Detail

This stained-glass window combines parts of two windows originally installed in the Lady Chapel of the Church of Saint-Germain-des-Prés in Paris in the mid-1200s. The two men on horseback in separate quarter circles near the center of the window are the 6th-century king Childebert and his brother, Clothar, identified by their crowns and robes. They are on their way to fight the Visigoths in Spain, where, in victory, they obtained one of the relics of Saint Vincent, martyred there around the year 300. A relic is an item or body part thought to have belonged to a holy person, which then becomes an object of veneration. In this case, the relic was the saint's tunic, which the brothers brought back to Paris. An abbey, later known as Saint-Germain-des-Prés, was founded to receive it. Look around this gallery (and in nearby 305 and 306) for reliquaries, or containers for relics, in a variety of shapes, from a basic house shape (probably meant to represent a church or tomb) to fully representational busts of saints.

Medieval Sculpture Hall

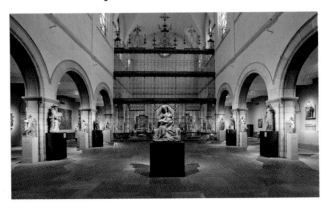

The space in which you are standing was once the principal gallery of the Museum; the compact two-story building opened in 1880, ten years after the Met was founded. This soaring hall was initially filled with antiquities from Cyprus and, later, with large plaster casts of architectural elements. Now, it houses works of European medieval art from the 14th and 15th centuries, including the Burgundian Virgin and Child facing the entrance (opposite; ca. 1415–17, attributed to Claus de Werve) and a number of tapestries on the south wall. Tapestry is an ancient art form that reached a new height of refinement in the medieval period. Highly prized for decorating interiors of all sorts, tapestries had the additional attraction that they could be carried from one residence to another: they were portable grandeur. Designed by the leading artists of the day, they embraced a wide variety of themes, including religious parables and courtly romances. Because tapestries are extremely delicate and susceptible to fading, the display is changed periodically.

More medieval art is on view in the adjacent galleries and at The Cloisters, the Museum's branch in northern Manhattan.

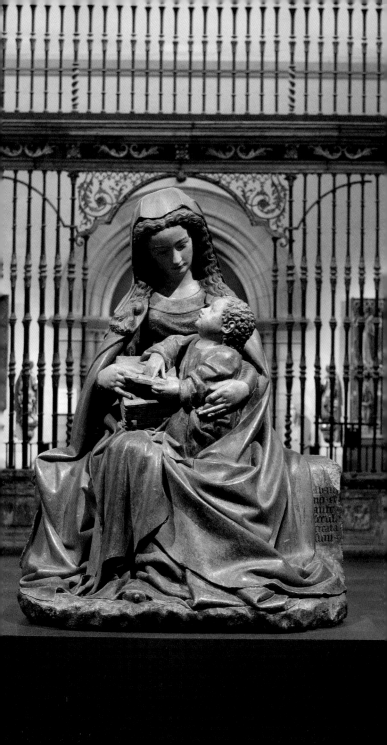

Goya (Spanish, 1746–1828)

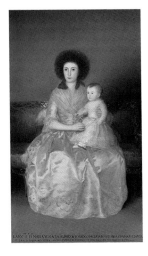

*Countess of Altamira
and Her Daughter*, 1787–88

This wing of the Museum displays the collection of the banker
and distinguished art connoisseur Robert Lehman. It was designed
to re-create the atmosphere of his New York home, forming some-
thing of a museum within a museum. One of Lehman's treasures
was Goya's portrait of the Countess of Altamira and her daugh-
ter, painted in the late 1700s. Portraiture—especially of powerful
officials and aristocrats—was a centerpiece of Goya's long career.
After painting portraits of five directors of Madrid's leading bank,
Goya was engaged by one of the bankers, the Count of Altamira,
to paint his wife and children. Goya's command of his technique
is visible here in the expert handling of light on the mother's
silk dress and in the translucent layers of the baby's skirt. He
combined this virtuosity with fresh and honest observation of
human character, as seen in the figures' facial expressions.

A famous portrait of the Altamiras' son Manuel Osorio, also by
Goya, hangs upstairs in gallery 612.

Robert Lehman Wing

J.-A.-D. Ingres (French, 1780–1867)

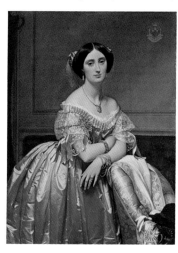

Princesse de Broglie, 1851–53

Here is another portrait of an aristocratic woman once owned by Robert Lehman. The French artist Jean-Auguste-Dominique Ingres painted the Princess of Broglie about sixty years after Goya portrayed the Countess of Altamira (opposite). Critics applauded him for capturing "a delicious incarnation of nobility." He achieved this effect through the princess's pose, demeanor, porcelain-like flesh, and exquisitely detailed, fashionable dress. Ingres's portraits fascinate us with their degree of precision, seeming more realistic than a photograph—yet a closer look at this one reveals certain idiosyncratic qualities that define the sitter. Notice her almost boneless fingers and the lack of modeling in her shoulders and neck. By substantially altering the human form, Ingres seemingly anticipated the work of many later artists.

The princess died young, and her grieving husband kept this picture covered in velvet for the rest of his life.

More works by Ingres are on view upstairs in gallery 801.

Robert Lehman Wing

Grand Salon from the Hôtel de Tessé, 1768–72

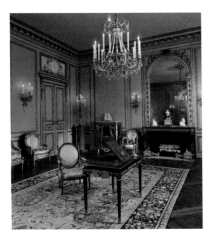

The interiors of 18th-century France were legendary for their sumptuous decoration. Some visitors, especially Americans of the time, treated this opulence with suspicion. In 1778, on a trip to Europe, the future president John Adams wrote, "I cannot help suspecting that the more elegance, the less virtue." A room like this would surely have tested Adams's hypothesis. Everything in it was contrived to seduce and charm. Unlike the Italian Renaissance *studiolo* you saw earlier (p. 21), this was a space to be shared—albeit with very special guests in a Parisian private house (*hôtel particulier*). The room now contains superb pieces that once belonged to the French queen Marie-Antoinette, including the mechanical table in the middle of the room, which was delivered to her one week before the birth of her first child (it converts from a reading or writing table to a dressing table with mirror to a dining table).

Other historic interiors, or "period rooms," from France, Italy, and England can be found in the surrounding galleries; the American Wing contains twenty more examples.

The Wrightsman Galleries

Carroll and Milton Petrie European Sculpture Court

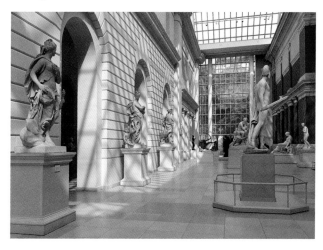

This inviting space has the feeling of the outdoors; in fact, it used to be located outside the Museum. The brick wall through which you likely just passed was once the Museum's south facade— the carriage entrance from Central Park. The space was enclosed in 1990 as a setting for French and Italian sculpture. The standing male nude in the center, holding the severed head of Medusa, is the mythological hero Perseus. The Italian master Antonio Canova made two versions of the work, both loosely based on the ancient Roman sculpture known as the Apollo Belvedere, a treasure of the Vatican. After Napoleon whisked the Apollo off to Paris in 1797, Pope Pius VII placed Canova's first version of Perseus in the niche where the Apollo had formerly stood, thus championing contemporary Italian art and defying Italy's French conquerors. (The Vatican eventually got the Apollo back.) The second version of Perseus, ordered from Canova by a Polish countess and carved in 1804–6, came to the Metropolitan in 1967.

Georgia O'Keeffe (American, 1887–1986)

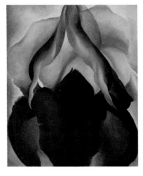

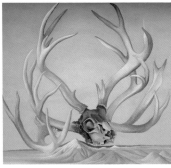

Black Iris, 1926

From the Faraway, Nearby, 1937

Lila Acheson Wallace Wing

For seven decades, Georgia O'Keeffe was a major figure in American art. With keen powers of observation and great facility with a paintbrush, she sought out nature's essential forms, recording the subtle nuances of color, shape, and light she perceived in her surroundings. *Black Iris* is one of O'Keeffe's early masterpieces. Inspired by the aesthetics of modernist photography and techniques such as the extreme close-up, she magnified the petals far beyond lifesize proportions, achieving a near-abstract expressiveness that is often read as sexual. When her large-scale flower paintings were first exhibited in 1925, even her husband, the photographer Alfred Stieglitz, was struck by their audacity—and they remain powerful almost a century later. In 1935 O'Keeffe began to experiment with compositions combining sun-bleached animal bones and Southwestern landscapes, without regard to scale or perspective. Despite her realistic painting technique, these works, like her flowers, were hardly mirror images of reality. In *From the Faraway, Nearby,* the skull, with its extravagant number of antlers, is an imaginative invention.

The Esther Annenberg Simon Gallery

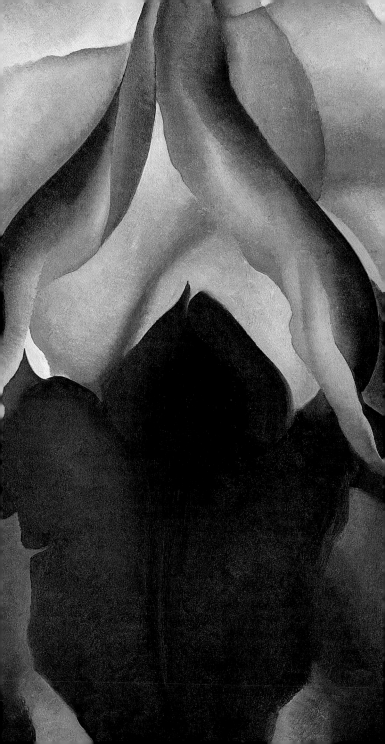

The Jan Mitchell Treasury

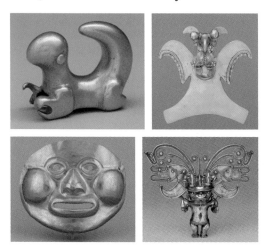

Clockwise from top left: Pendants (Panama, Costa Rica, Colombia) and funerary mask (Colombia), 5th century B.C.–16th century A.D.

The Michael C. Rockefeller Wing

Gold has mesmerized humanity through the ages and across the world—remember the gilded furniture in the French grand salon and the splendid armor of George Clifford (pp. 19, 32). In the civilizations of Precolumbian America, such as the Aztec of Mexico and the Inca of Peru, the material itself was endowed with spiritual and symbolic meaning. To own and wear gold was the privilege of rulers. After Columbus, the natural gold deposits of the Americas became a fervent obsession of foreign explorers, conquerors, and colonists, all searching for precious metal to melt down into bullion. For the ancient Americans themselves, however, gold increased in value when it was worked into potent images, such as those housed in this treasury. Look carefully and you'll find abstract depictions of the human form as well as a beguiling array of animal-shaped objects; eagles, bats, and crocodiles are particularly plentiful, both on their own and in various hybrid creatures.

El Anatsui (Ghanaian, b. 1944)

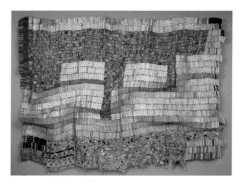

Between Earth and Heaven, 2006

The Michael C. Rockefeller Wing

Just as gold, in parts of Precolumbian America, was worn exclusively by rulers, so wearing kente, the dazzling strip-woven textile produced by Akan and Ewe weavers in Ghana and Togo, was originally a privilege of the elite. Today, the cloth is available much more widely, in a great variety of geometric designs and color schemes; in the West, it has come to be seen as a symbol of all things African. In this resplendent wall-hung sculpture, the Ghanaian-born artist El Anatsui plays on those associations as well as other historical and contemporary issues, such as the legacy of the slave trade, alcohol consumption, and the detritus of consumerism. The work evokes the design and construction of kente in a very different material: thousands of discarded aluminum caps and seals from recycled liquor bottles, which Anatsui and his assistants flattened, perforated, arranged, and painstakingly assembled with copper wire. The result is a powerful example of the vitality of contemporary expression in Africa and of the continuity that exists with classical forms of expression from sub-Saharan Africa, which are the focus of the Met's collection and can be seen throughout this large gallery.

Samuel H. and Linda M. Lindenbaum Gallery

Queen Mother Pendant Mask, 16th century

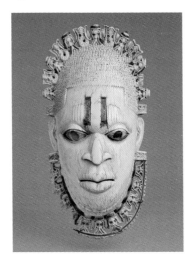

The Michael C. Rockefeller Wing

This finely carved ivory mask comes from the Edo peoples of the kingdom of Benin, in present-day Nigeria. It is the idealized depiction of a specific individual: Idia, the mother of King Esigie, who commissioned it in the early 1500s. Idia was the king's most trusted advisor. He honored her by creating the title Iyoba, or "Queen Mother"; empowered her equally with senior male chiefs; and immortalized her in a series of remarkable portraits, including this one. The image captures her virtues, rather than just recording her appearance; the composure of the face, in particular, seems to reflect her wisdom and strength. But the object is more than an idealized likeness. It was worn as a protective amulet by the king during state rituals. Look closely at the locks of hair, rendered alternately as miniature Portuguese merchants and stylized mudfish. The merchants allude to the wealth the court derived from trade with Portugal, while the mudfish, able to survive both on land and in water, are a metaphor for the king's dual nature: both human and divine.

The Benenson Gallery

Bis Poles, mid-20th century

The Michael C. Rockefeller Wing

Among the Asmat people of New Guinea, deaths are thought to create a dangerous imbalance that must be remedied by the living, in part by creating *bis*, or ancestor, poles. A group of men carve each pole from a single tree, leaving one of the roots attached so that it projects from the top when the pole is erected. Each figure on the pole represents a specific person who has died. Once the poles are complete, the community holds a feast to honor the deceased and send their spirits on to the world of the ancestors. Then, the poles are taken to a grove of sago palms, where, as they decay, their supernatural power is believed to seep into the ground, ensuring an abundant harvest of sago, an essential food source. The destructive forces of death are thus converted into nourishment for the living. Most of the poles in the Met were procured by the late Michael Rockefeller, who was conducting research in New Guinea when he disappeared in November 1961 at age twenty-three. The Rockefeller family gave the works of art that Michael had collected to the former Museum of Primitive Art, from which they came to the Met in 1978.

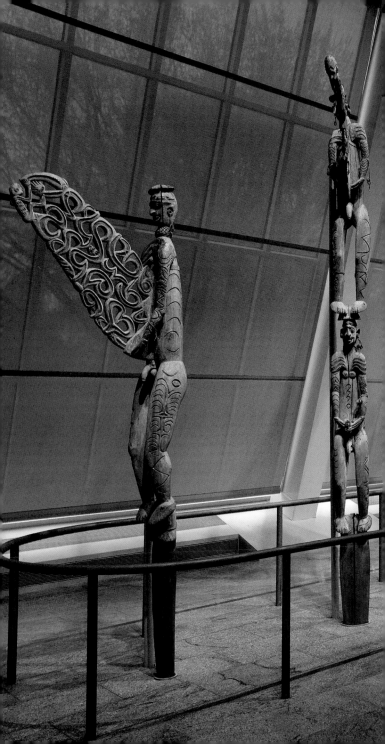

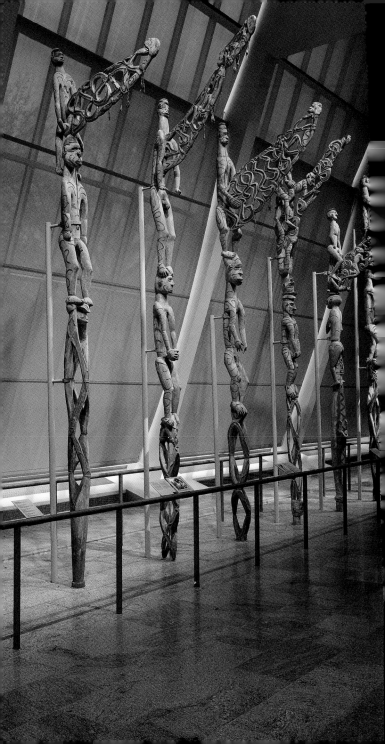

Sarcophagus with Triumph of Dionysos and the Seasons, ca. 260–70

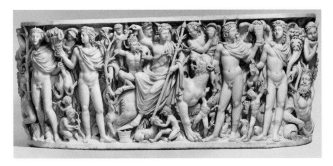

The commemoration of the dead has been a major function of art throughout history—think of the tomb of Perneb, where this visit began, or the *bis* poles of New Guinea (pp. 8, 41). The present work is a marble sarcophagus, or decorated coffin, of the late 3rd century A.D. According to ancient Roman custom, it would have been placed in a small, aboveground structure where relatives could come to honor the memory of the deceased. The marble was carved so deeply that many of the figures stand almost in the round, with rich pockets of shadow surrounding them. The figure sitting on the panther in the center is Dionysos, god of wine, amid a throng of his followers. The four full-length male figures flanking him are personifications of the seasons, suggesting that the revels will last through the passage of time.

This space, designed by the noted American architecture firm McKim, Mead and White to resemble the garden courtyards of ancient Roman villas and town houses, first opened in 1926. For many years, it was the Museum's public restaurant. In 2007 it reverted to its original purpose: the display of art.

Leon Levy and Shelby White Court

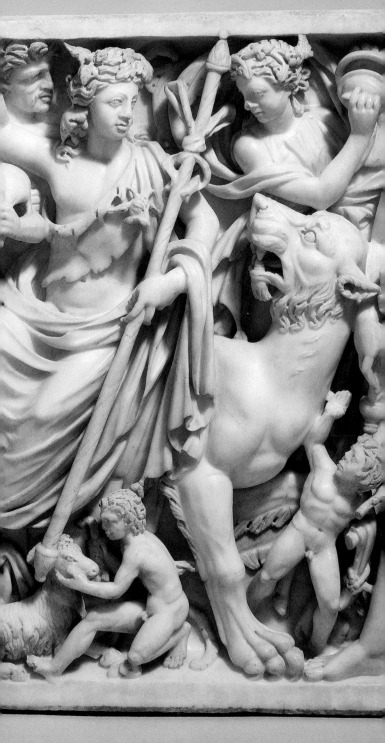

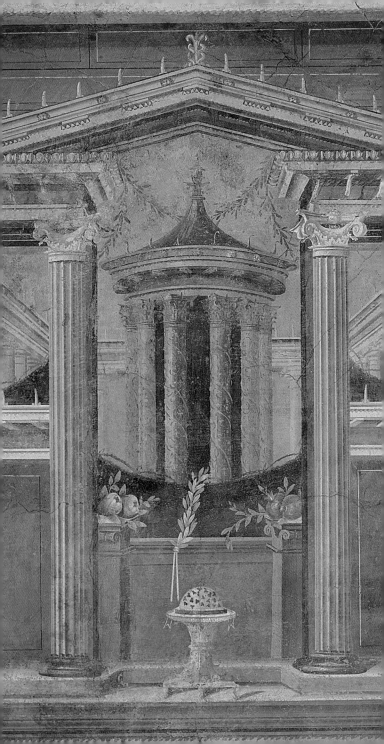

1

Cubiculum from Boscoreale, ca. 50–40 B.C.

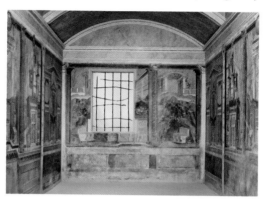

In the year 79, the eruption of Mount Vesuvius in southern Italy buried the nearby towns of Pompeii and Herculaneum and a number of smaller settlements under ash and debris. The volcanic material preserved many ancient buildings, including the luxury villa near Pompeii that contained this cubiculum, or bedroom. Scenes of nature and architecture unfold on every side, framed by red columns atop a low wall. Visual ambiguities tease the eye: the columns cast shadows, for example (calling to mind the Gubbio *studiolo* on p. 21), and on the back wall, a glass fruit bowl sits temptingly on a ledge.

Remarkably, the vibrant colors are original. The walls were decorated in the true fresco technique, which involved painting directly on a very smooth layer of wet plaster containing alabaster or marble dust, then burnishing the surface once it had dried. The pigments were thus sealed into the plaster, and the burnishing produced areas of high gloss. The red pigment so abundant in these paintings is cinnabar, one of the rarest and most valuable—a signifier of the villa owner's substantial wealth.

Another reconstructed Roman room and other wall paintings can be seen in galleries 164, 166, and 167.

Bronze Statuette of a Veiled and Masked Dancer, 3rd–2nd century B.C.

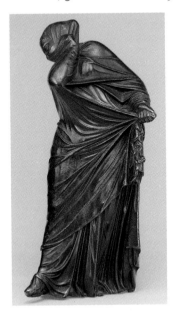

We now move to Alexandria, Egypt, founded by Alexander the Great in 331 B.C., well before the Roman Empire of the previous two stops. This bronze statuette was probably made there; the figure has been identified as one of the entertainers for which the cosmopolitan city was famous, a combination of mime and dancer. The dancer's complex motion is conveyed exclusively through the interaction of her body with several layers of dress. Over a heavy floor-length garment, she wears a lightweight mantle, drawn tautly over her form by the pressure of her protruding right arm, right leg, and left hand. Except for her eyes, her face is covered by the sheerest of veils, discernible at its edge below her hairline. Unlike in Antico's naked *Spinario* (p. 26), which is about the same size as this work, hardly an inch of skin is visible—yet it is hard to imagine a more powerful demonstration of interest in the human body.

Statue of a Kouros, ca. 590–580 B.C.

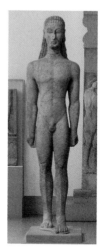 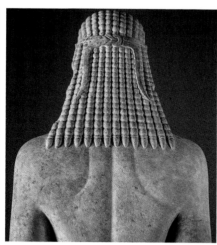

When this statue was made, shortly after 600 B.C., Greek sculptors were beginning to represent the human form in three dimensions, in stone and on a large scale. Early efforts such as this one show how much they learned from Egyptian tradition, which was by then already ancient; seen from the side, the sculpture echoes the pose of its Egyptian predecessors. A significant Greek innovation, however, was the nude, which carried connotations of vigor, beauty, and even moral excellence. Despite its abstract features (greater detail would have been painted on in color), this kouros—Greek for "youth"—has a lifelike look: the sculptor made it stand independently, with no additional support, like a human being in real space. In addition to conveying a sense of self-reliance, this was also a significant technical achievement, given that the figure weighs two thousand pounds. Later generations of Greek sculptors created ever more lifelike figures, as you can see in the galleries nearby: look for bodies in fluid motion and muscles and flesh more naturally rendered.

Judy and Michael H. Steinhardt Gallery

Visit Two: Second Floor

The American Wing

Musical Instruments

European Paintings, 1250–1800

Modern and Contemporary Art

MEZZANINE

19th- and Early 20th-Century European Paintings and Sculpture

Art of the Arab Lands, Turkey, Iran, Central Asia, and Later South Asia

Ancient Near Eastern Art

Great Hall Balcony

Asian Art

VISIT BEGINS IN GALLERY 206

Second Floor

GALLERIES 206–921

Our tour of the Met's first floor left us off in Greece during the 6th century B.C. The second-floor path begins 1,200 years later, in the 6th century A.D., in China, and ends in New York City in the 1980s. Along the way, you will visit the galleries of seven curatorial departments:

- Asian Art
- The American Wing
- Musical Instruments
- European Paintings
- Ancient Near Eastern Art
- Islamic Art (Art of the Arab Lands, Turkey, Iran, Central Asia, and Later South Asia)
- Modern and Contemporary Art

When you have finished, perhaps you will have time to visit one of the Museum's special exhibitions, or to retrace your steps to a gallery you found particularly compelling. And come back— I can guarantee that the Met will always reward your visits with new experiences and insights.

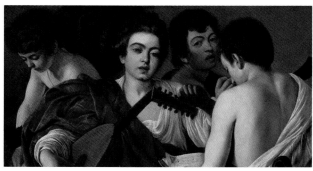

Gallery 621 (page 66)

Chinese Buddhist Art

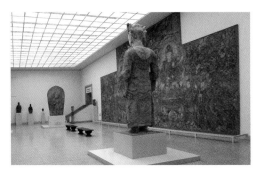

Bodhisattva (seen from behind), ca. 550–60; Buddha of
Medicine Bhaishajyaguru mural, ca. 1319

Florence and Herbert Irving Asian Wing

The monuments in this gallery were all made for Buddhist sites in
China. Buddhism originated in India in the 5th century B.C. and
spread throughout Asia—it is a thread connecting the continent's
many civilizations, though it was modified and embellished by
each of them. A core goal of Buddhist practice is to transcend desire
and suffering in the state of complete understanding known as
enlightenment. One who has done so is called a Buddha; the Bud-
dha of our historical era was Siddhartha Gautama, but Buddhists
believe that there are others, from other eras and even other uni-
verses. The enormous mural in this gallery represents one such
heavenly Buddha, wearing a red robe and surrounded by deities
and guardians. The colossal statue standing near the mural depicts
a bodhisattva, a saintly guide who, deferring his own enlighten-
ment, remains in the material world to help others. Its powerful
sense of volume reflects the Indian idea that physical perfection
mirrors spiritual advancement, but the fluttering sashes have a
linear quality that is typically Chinese. The jewelry is also an
amalgam of Chinese and foreign imagery: the arrow-like elements
and disks with holes can be traced to early Chinese cultures,
while the pearl clusters reflect Central or West Asian traditions.

Arthur M. Sackler Gallery

Female Dancer, 2nd century B.C.

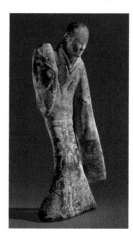

Florence and Herbert Irving Asian Wing

The objects in the first part of this gallery display the development of Chinese culture in antiquity, before the introduction of Buddhism. Near the middle of the gallery are objects from the Han dynasty, China's first significant imperial age, which lasted for more than four hundred years, from about 200 B.C. to A.D. 220. Concurrent with the Roman Empire and just as large, the Han established an effective centralized administration that remained the model of Chinese rule for over two thousand years.

About halfway down on the left side of the gallery, in a case by itself, is an elegant female dancer in a long-sleeved robe, one of a group of pottery attendants buried in a high-ranking individual's tomb in the 2nd century B.C. With remarkable economy and expressiveness, the artist suggested the slow, graceful movement of a dance performed for the entertainment of the deceased. Many of the objects nearby are also "spirit goods"—models of things the tomb owner might need in the afterlife, similar to those you saw in the Egyptian galleries on the first floor (p. 10).

Charlotte C. Weber Galleries

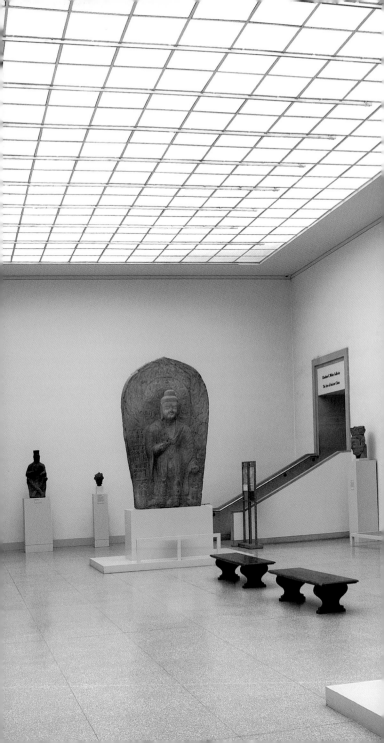

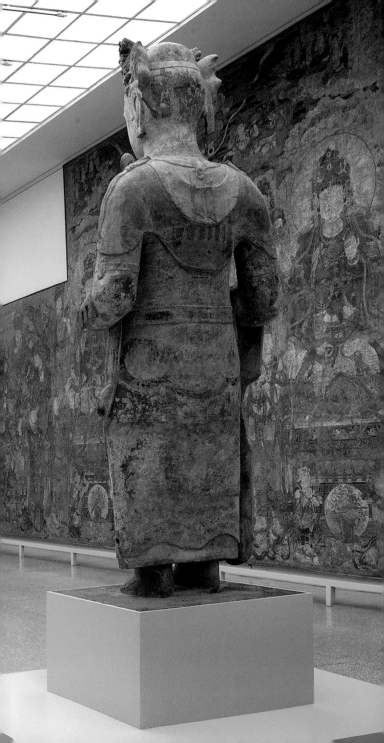

The Astor Court

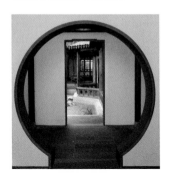

Florence and Herbert Irving Asian Wing

This space, based on a 17th-century garden in Suzhou, a city on the Grand Canal just west of Shanghai, was the brainchild of the late philanthropist Brooke Astor, who spent part of her childhood in China. All the garden's elements were crafted by hand in Suzhou and assembled here in 1980 by twenty-seven Chinese artisans and engineers. It was the first such cultural exchange between the United States and the People's Republic of China. For the pillars, the Chinese government granted special permission for the logging of the rare *nan* tree, and a former imperial kiln was reopened to make thousands of bluish-gray tiles for floors and trim.

After you enter through the distinctive moon gate (above), a covered walkway guides you along one side of the court. Your view of the panorama laid out along the opposite wall—an elaborate arrangement of Taihu rocks surrounding a half-pavilion with exuberant upturned eaves—shifts with every step. The experience mimics the act of looking at a Chinese painted handscroll as it is unrolled. Rugged stepping-stones mark transitions between the worlds of architecture and nature.

Exhibited in nearby galleries (210–216) are exceptional examples of Chinese painting and calligraphy. The display is changed continually to preserve these light-sensitive works on silk and paper.

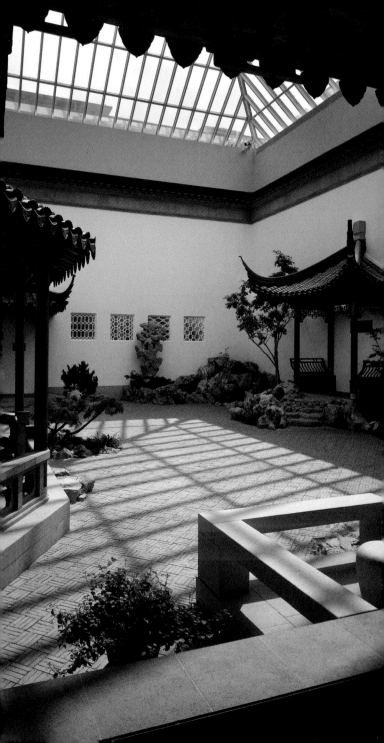

Dancing Celestial, early 12th century

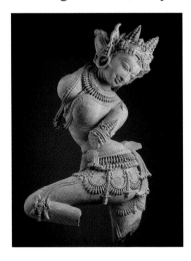

Florence and Herbert Irving Asian Wing

The sensual form and complex contour of this dancing celestial being are typical of sculpture from 12th-century central India. The head is turned in one direction, the chest in another, and the hips in yet another. It is a pose almost impossible to strike in real life, yet the sculptor has made it look wonderfully graceful and natural in sandstone. The dancer's delicate adornments accentuate the smooth forms of her flesh (note, for example, the contrast between her serenely composed face and the elaborate, jagged tiara). Hinduism emerged in India in the last millennium B.C., combining local nature cults with deities derived from ancient Sanskrit texts. Hindu temples are considered the literal earthly homes for the gods, where believers can commune with the divine through various types of worship. A sacred image of a particular deity, such as Vishnu or Shiva, would have been the focus of the temple, housed in its main sanctuary; other sculptures, such as this one, were installed on the exterior walls to evoke the temple's function as a heavenly abode.

Florence and Herbert Irving Galleries

Dainichi Nyorai, 12th century

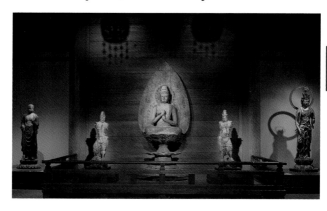

2

The Sackler Wing

The figure seated on a lotus pedestal in the center of this gallery is the Buddha in his cosmic manifestation as the supreme divinity, from whom everything in the universe emanates. In Japanese, he is known as Dainichi Nyorai, or "Buddha of Great Radiance." Most surviving early Buddhist images from India and China are stone or bronze, but this one from Japan, like the others displayed here, was carved from wood. It was then coated with lacquer, painted, and gilded—though much of the decoration has been lost.

As you proceed on your route, you will pass through several other galleries devoted to Japanese art (225–227), with changing displays of screens, woodblock prints, scroll paintings, textiles, and other art forms. You will also see—and hear—a sculpture made especially for these galleries in 1986 by the Japanese American artist Isamu Noguchi (more visible in gallery 229, on the opposite side). *Water Stone* embraces the contrasts and paradoxes found in nature; the water that flows upward through the work, coating it evenly on the top and all sides, gradually erodes the heavy basalt over which it spills.

The Sackler Wing Galleries

Emanuel Leutze (American, 1816–1868)

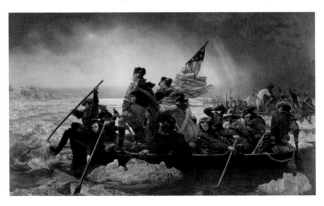

Washington Crossing the Delaware, 1851

The Joan Whitney Payson Galleries

Leutze's depiction of a critical moment during the Revolutionary War is one of the best-known images in American art. It shows George Washington and some of his troops traversing the Delaware River about nine miles above Trenton, New Jersey, in a surprise attack on the Hessians (German soldiers hired by Great Britain). The strategic crossing took place after midnight on December 25, 1776. The artist clearly took liberties with the historical details of his subject; he was most interested in conveying the *idea* of heroism—in making a rhetorical splash—and his picture certainly did so. When it was first exhibited, in New York in 1851–52, more than 50,000 people paid to see it. Later, during the Civil War, at a fund-raiser for the Union cause known as the New York Metropolitan Fair (to benefit the United States Sanitary Commission), it was hung in an elaborate gilded frame with an eagle crest that was later lost but painstakingly re-created for the opening of these renovated galleries in 2012. A Mathew Brady photograph of the fair's picture gallery is mounted on the railing in front of the painting.

Peter Jay Sharp Foundation Gallery

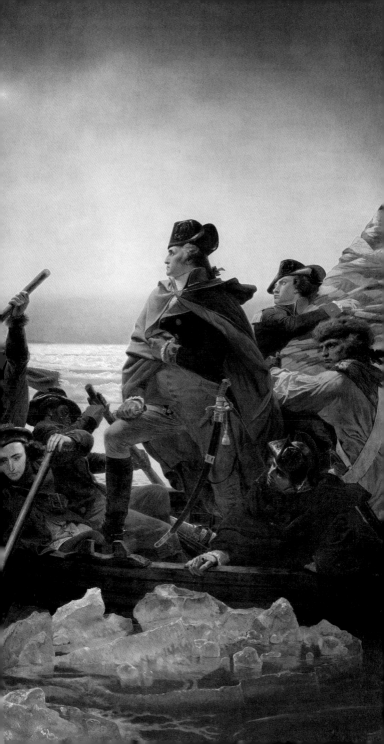

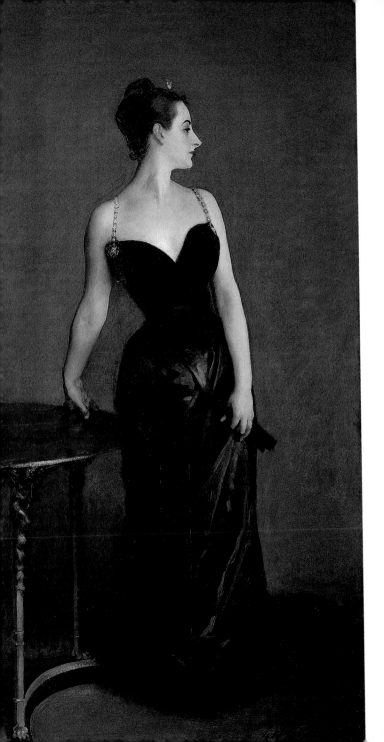

John Singer Sargent (American, 1856–1925)

2

Madame X (Madame Pierre Gautreau), 1883–84

The Joan Whitney Payson Galleries

The expatriate John Singer Sargent met Virginie Amélie Avegno Gautreau (1859–1915) in Paris, probably in 1881. Born in Louisiana and married to a French banker, Madame Gautreau was a celebrated, if unconventional, beauty. In his striking profile view of her, Sargent accentuated her long nose and high forehead and called attention to her hennaed hair, her rouged ears, and the lavender-tinted powder she applied to her pale skin. He painted the portrait without a commission, hoping to enhance his reputation in Paris. However, when he exhibited it at the Salon of 1884, Madame Gautreau's bizarre glamour and her dress, with its low-cut bodice and its right strap falling off her shoulder (later repainted), were shocking for a society portrait—notwithstanding the many female nudes that appeared in paintings of mythological or allegorical subjects. Madame Gautreau was not identified in the catalogue, but everyone recognized her. The portrait embarrassed her and her family and prompted Sargent to reconsider his professional prospects in Paris. He settled in London in 1886.

Terian Family Gallery

Harpsichord, ca. 1670

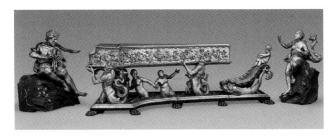

Geographically and chronologically, the Metropolitan's Depart-
ment of Musical Instruments presents a cross section of the rest
of the encyclopedic collection; the sole common denominator of
the department's wildly diverse holdings may be that the works
were meant to be experienced primarily through sound rather
than sight. Still, they provide ample visual interest. For instance,
this gilded-wood harpsichord ensemble is a perfect example of
the flamboyant and monumental Roman Baroque style of the
17th century. The long frieze on the case depicts the sea nymph
Galatea's escape from Polyphemus, the murderous, man-eating
Cyclops who loves her; Galatea herself and her nemesis, playing
a type of bagpipe, are the flanking figures, seated on artificial
rocks. Michele Todini, instrument maker and inventor, built and
sculpted the ensemble and exhibited it to the public in his Galleria
Armonica e Matematica in Rome. Later, between 1889 and 1918,
it was among the thousands of musical instruments given to the
Museum by Mrs. John Crosby Brown, whose broad collecting
habits set the tone for the department's acquisitions in the years
to come.

The André Mertens Galleries for Musical Instruments

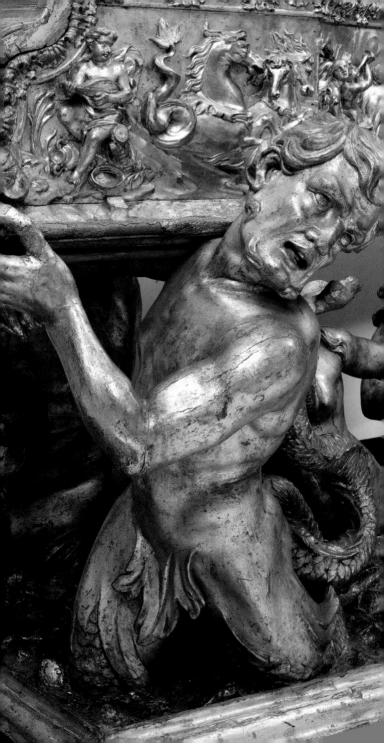

Caravaggio (Italian, 1571–1610)

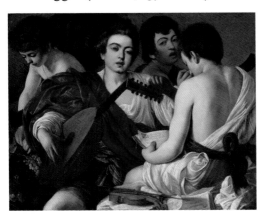

The Musicians, ca. 1595

It is fitting that the first painting you encounter on this itinerary, after leaving the galleries for musical instruments, is Caravaggio's *Musicians*, painted in Rome for the artist's great early patron, Cardinal Francesco del Monte. The cardinal was a connoisseur of music as well as art. The young painter from the North (Lombardy) lived in the cardinal's palazzo from 1595 to 1601 and was surrounded there by beautiful objects, including musical instruments; the fourteen-peg lute shown in this work was probably in the cardinal's collection. The models are also beautiful, all pearly white flesh exposed by loose, vaguely classical-looking drapery. The lutenist in the center, with his parted lips and moist eyes, is rife with sensuality, while the dark-eyed cornetto player behind him, looking straight out at the viewer, is likely Caravaggio himself. This work is in the artist's early manner, bathed in a clear, even light. He had not yet delved into the dramatic extremes of light and dark that would become one of his trademarks—resolutely on display in his late *Denial of Saint Peter*, also hanging in this gallery.

Botticelli (Italian, 1444/45–1510)

2

The Last Communion of Saint Jerome, ca. 1495–1500

This deeply moving work was painted by the same artist who, earlier in his career, created some of the most famous mythological paintings of the Renaissance: the *Birth of Venus* and the *Primavera*. It has little in common with those sensual works, for the cultural climate of Florence had changed under the leadership of the radical Dominican preacher Savonarola. Botticelli may have been one of his followers, as was the man who commissioned this picture, the wool merchant Francesco del Pugliese. Pugliese was present in the convent of San Marco on the night Savonarola was arrested by his political opponents, in April 1498; shortly thereafter, the friar was tried and burned at the stake. Saint Jerome, the renowned 4th-century translator of the Bible into Latin, is shown in his hermit's cell near Bethlehem, receiving his last communion from a fellow monk. Looking on with concern and compassion, two other monks assist the elderly scholar, who is very near death. Pugliese was doubtless attracted to the subject of Jerome in his cell for its intensely devotional content.

El Greco (Greek, 1540/41–1614)

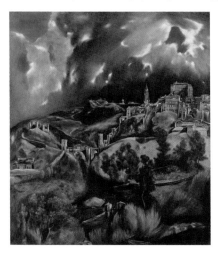

View of Toledo, ca. 1597–99

El Greco, whose name means simply "the Greek" in Spanish, was born Domenikos Theotokopoulos on the island of Crete, where he learned to make icons, sacred paintings for Eastern Orthodox churches. He was introduced to Italian painting in Venice, then settled in the Spanish city of Toledo. The lurid colors of this landscape, and the way the forms float and twist into unusual shapes, are equally characteristic of the artist's treatments of the human figure—see his *Vision of Saint John*, also in this gallery. El Greco's work strikes most viewers as uncannily modern. It seems charged with strong emotion and subjectivity, conveyed through an extremely daring aesthetic approach. Picasso was one of those dazzled viewers (the *Vision* was an inspiration for his 1907 masterpiece *Demoiselles d'Avignon*); two others were Harry (H. O.) and Louisine Havemeyer, donors of so many splendid works of art to the Metropolitan, including *View of Toledo* and *Portrait of a Cardinal*. In the late 19th century, Mrs. Havemeyer wrote of El Greco, "We could not resist his art; its intensity, its individuality, its freedom and its color attracted us with irresistible force."

Johannes Vermeer (Dutch, 1632–1675)

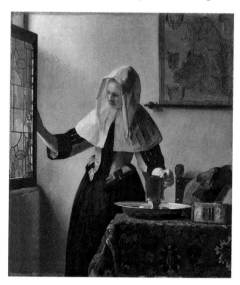

Young Woman with a Water Pitcher, ca. 1662

Vermeer was not prolific: only thirty-six paintings by him are known to exist today, and five of them are here at the Metropolitan. A native of Delft, in the Netherlands, he is best known for his pictures of quiet interiors, populated by women. Vermeer invested these simple scenes with a sense of poetic truth. He had a spellbinding talent for capturing every nuance of light's optical effects, from the play of brightness and shadow on the crisp white fabric that covers the woman's head and shoulders to the diffuse illumination of the wall behind her and the gleaming highlights on the pitcher and basin. The composition is exquisitely structured, with every element in perfect balance. The image seems entirely self-contained, yet it points to faraway places—the carpet on the table is a Turkish import, and the map suggests the possibilities of travel and trade (Delft was a home port of the Dutch East India Company). Similar props can be seen in many of Vermeer's other works.

Rembrandt van Rijn (Dutch, 1606–1669)

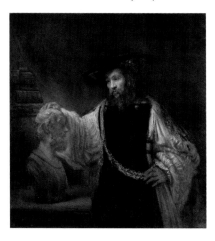

Aristotle with the Bust of Homer, 1653

The profound humanity of this image and its dramatic contrasts of light and dark are hallmarks of Rembrandt, who worked in Amsterdam during the 17th century, known as the golden age of Dutch painting. He created the picture for an Italian patron who ordered an image of a philosopher, not specifying which one. Rembrandt chose Aristotle. Wisdom, of course, is not a visible trait, yet artists in many cultures have sought to capture it— think of the Buddhas and bodhisattvas in the galleries for Asian art (pp. 52, 59). Here, the philosopher stands in darkness, but light shines on his face, his sleeves, and his right hand, which rests on a bust of the epic poet Homer. Instead of fixing his eyes on the bust, however, he seems to focus inward, and his care-worn face suggests the melancholy of solitary insight.

This same inward focus is evident in Rembrandt's approximately forty extant self-portraits, a monument to his extraordinary talent and an eloquent and candid record of human mortality and the aging process. The Museum's example (in nearby gallery 634) shows the artist at fifty-four years old, wearing his working clothes.

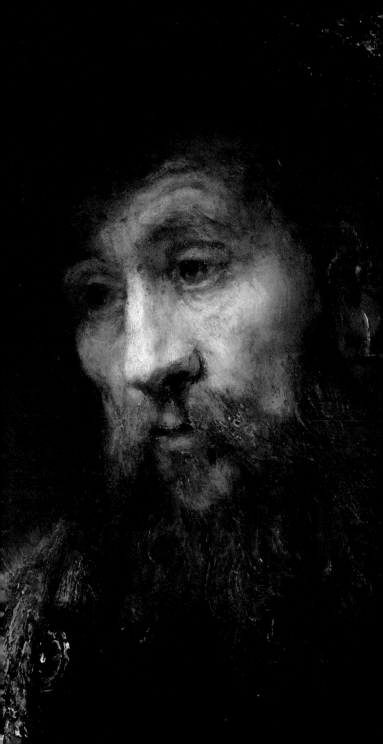

Giovanni Battista Tiepolo (Italian, 1696–1770)

The Triumph of Marius, 1729

Giovanni Battista Tiepolo was the greatest Italian artist of the 1700s. He had a genius for presenting scenes from history and myth in a vividly dramatic way, like theater on a grand scale. His massive painting cycles functioned as complete environments, surrounding their viewers in sumptuous rooms. He created the examples in this gallery for a *palazzo* on the Grand Canal belonging to his early patrons in Venice, the Dolfin family. The tall picture on the wall between the glass doors represents a moment in ancient Roman history, when the victorious general Marius, riding high in the chariot on the right, paraded a captive king before the people; the prisoner is the defiant red-cloaked figure in the foreground. There is a sense of drama even in the details: notice the rippling yellow banner near the top and the play of light and shadow over every surface.

From here, consider taking a detour into the Robert Wood Johnson Jr. Gallery (690), where rotating installations of works on paper—drawings, prints, and photographs—form perfect little thematic exhibitions. Or walk straight along the balcony and turn right to proceed directly to the next stop.

The Dr. Mortimer D. Sackler and Theresa Sackler Gallery

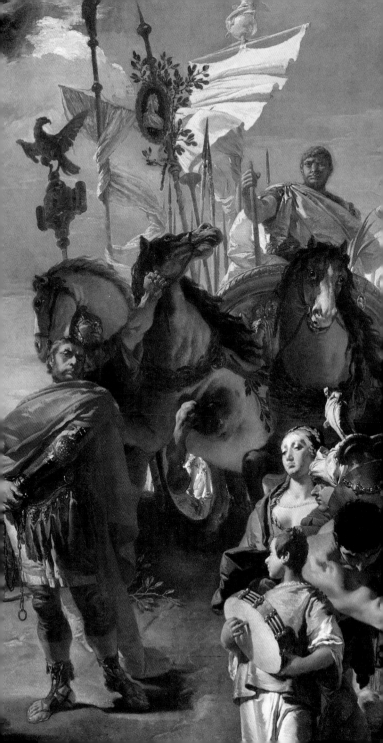

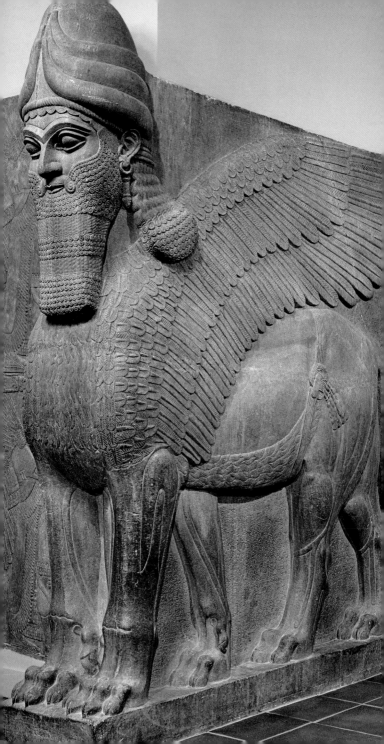

Reliefs from the Palace of Ashurnasirpal II, ca. 883–859 B.C.

2

The works seen here were carved for a royal palace at Nimrud, in what is now Iraq. In the 9th century B.C., when the palace was constructed, Nimrud became the capital of the formidable Assyrian Empire. Its territory was in the part of the world known as the ancient Near East, which stretched from the eastern Mediterranean to western Central Asia and produced a succession of dynamic cultures over eight thousand years. The Metropolitan has been involved in archaeological expeditions in the region since 1931, although the palace containing these works was excavated in the 1840s by a British team. The decoration was intended to reflect the majesty and divine right of the king, Ashurnasirpal II. On the walls, in low relief, are images of the king (bearded, with a distinctive conical cap) and members of his entourage (beardless eunuchs and winged divine protectors); a band of cuneiform text continually repeats the king's various titles and accomplishments.

Raymond and Beverly Sackler Gallery for Assyrian Art

Introduction to Islamic Art

The Met's magnificent collection of Islamic art is displayed in
the Galleries for the Art of the Arab Lands, Turkey, Iran, Central
Asia, and Later South Asia. Here, the Museum's challenge was to
create a balance between two important cultural forces—region
and religion. While the works of art were made mostly by or for
Muslims, they originated in vastly disparate locations, from India
to Spain. In the installation, the curators decided to emphasize
that regional diversity. Even the types of stone used for the
floors of the individual galleries were largely sourced from the
regions represented.

This room, the introductory gallery, features masterpieces
from many of the regions, giving you a taste of the treasures to be
found in the circuit of rooms beyond. There are interconnections
and parallels everywhere. One thing you'll notice is the extraor-
dinary emphasis on words and text. Because of the importance of
God's revelations to the Prophet Muhammad (the Qur'an), cal-
ligraphy has been an artistic pursuit of the utmost prestige. Look
for Arabic inscriptions on every type of object, in every medium—
even hidden in layers of wood, as in the Qur'an stand (*rahla*) in
the center of this gallery.

Patti Cadby Birch Gallery

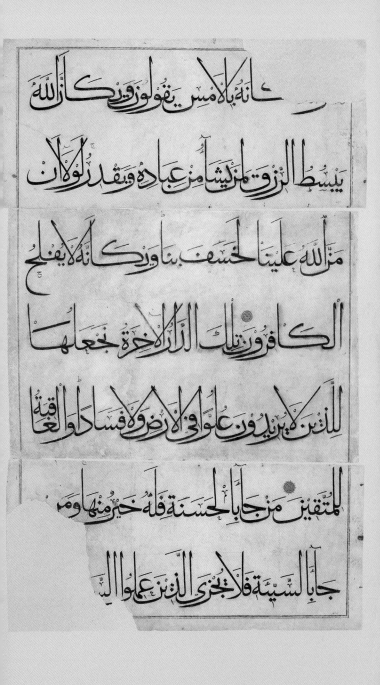

كانه بالامس يقولون ويكان الله

يبسط الرزق لمن يشاء من عباده ويقدر لولا ان

من الله علينا لخسف بنا ويكانه لا يفلح

الكافرون تلك الدار الاخرة نجعلها

للذين لا يريدون علوا في الارض ولا فسادا والعاقبة

للمتقين من جاء بالحسنة فله خير منها ومن

جاء بالسيئة فلا يجزى الذين عملوا الس

Prayer Niche (*Mihrab*), 1354–55

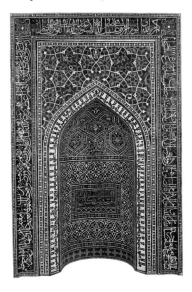

The *mihrab* is the focal point of the Islamic prayer ritual because it indicates the direction of Mecca, the birthplace of the Prophet Muhammad, on the Arabian Peninsula; from there, his followers spread his teachings to the rest of the Middle East, Turkey, Iran, North Africa, Spain, and, later, Central and South Asia. This *mihrab*, one of the earliest and finest examples of Islamic mosaic tilework, was once part of a prayer hall within a theological seminary in Iran. Intricate geometric patterns and arabesques in several shades of brilliant blue, white, and ocher envelop beautifully rendered Arabic inscriptions. A quotation from the ninth chapter (*sura*) of the Qur'an appears in the outermost border, and one from the sayings of the Prophet (hadith) frames the pointed arch, asserting, among other things, that whoever builds a mosque, "even the size of a sand-grouse nest," earns a place in Paradise.

The Damascus Room, 1707

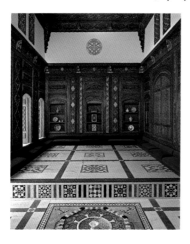

2

This winter reception room from Damascus, Syria, gives the flavor of an affluent merchant's house in the early 18th century, when the city was a provincial trading center within the Ottoman Empire. All around are signs of comfort and welcome. Every surface is richly decorated, from tiled floor to carved ceiling. Throughout, the woodwork is embellished with bands of vegetal and geometric ornament, images of fruit bowls and flower vases, and poetic inscriptions in Arabic. A similar, but more open, summer reception room would have been situated across a courtyard from this one. Be sure to explore the touch screen to your left, where a short video under "The Courtyard House" takes you through a 3-D rendering of the house.

The formidable Ottoman Empire, with its capital at Istanbul, often clashed with European forces. The large canvases by Tiepolo you saw a few galleries back (p. 72) were painted for a family involved in several campaigns against the Ottomans around the time this room was designed. In spite of the frequent hostilities, trade was seldom interrupted.

Gift of the Hagop Kevorkian Fund, 1970, in memory of its founder Hagop Kevorkian

Édouard Manet (French, 1832–1883)

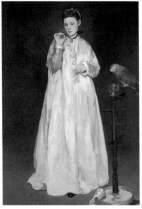
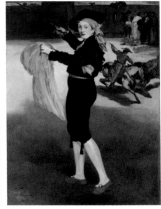

Young Lady in 1866, 1866

Mademoiselle V… in the Costume of an Espada, 1862

In 1866, when Manet exhibited the painting shown above on the left, Parisian critics were struck by the modernity of its subject. The young woman in a pale pink dressing gown was not taken from history, mythology, or the Bible, as was generally expected in serious art. Instead, she was just a woman of her time—a painter's model, posing, somewhat incongruously, beside a parrot on a perch, probably in the artist's studio. Manet likely created the work in response to an even more notorious canvas of the same year: *Woman with a Parrot*, by the Realist painter Gustave Courbet, which you can see in adjoining gallery 811. Considering the two paintings together in 1868, one critic exclaimed, "These realists are capable of anything!" Manet's painting was not meant as a portrait—no more than Courbet's was. The subject of the picture appears in costume, like an actress playing a role. Indeed, the same model, Victorine Meurent, appears in many guises in some of Manet's most celebrated works—including as a bullfighter in the painting shown on the right.

Claude Monet (French, 1840–1926)

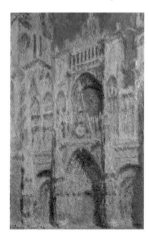

2

*Rouen Cathedral: The Portal
(Sunlight)*, 1894

Western painting was at a crossroads in the late 19th century:
the experiments of painters such as Courbet and Manet had
exploded the conventions of the old masters, and the invention of
photography had challenged painting's supremacy as a means
of recording the visual world. One of the artistic responses to
these conditions was Impressionism, and one of that movement's
pioneers was Claude Monet, whose pictures fill this gallery. Look
closely at any canvas. The surface shows distinct, visible brush-
strokes in a range of colors. Conservative critics labeled his early
work "sketchlike" or "unfinished." But from a comfortable dis-
tance, the strokes blend to form haystacks, poplar trees, water
lilies, or views of the seaside.

Monet began some of these paintings outdoors, where he was
able to study directly the changing effects of light and atmosphere.
Indeed, these effects became his primary subject. In 1890, he
started creating pictures in series. To paint the Gothic facade of
Rouen Cathedral, for instance, he set up several canvases and
moved from one to the next as the day progressed.

The Annenberg Galleries

Vincent van Gogh (Dutch, 1853–1890)

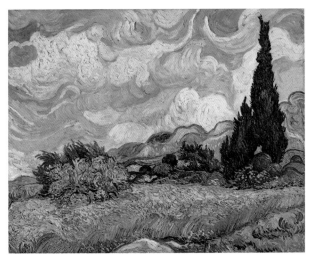

Wheat Field with Cypresses, 1889

When Van Gogh arrived in the South of France in 1888, he was drawn to the cypresses he saw scattered through the countryside. This canvas is one of several he painted featuring the majestic trees. The artist compared their form to that of Egyptian obelisks and described them as "a splash of black in a sunny landscape." The clarity of light and vibrant colors of the environment also appealed to him, as he had lived most of his life farther north, in less hospitable climes. In a letter to his brother Theo, Van Gogh called this work one of his "best" summer landscapes and likened its sky to "a multicolored Scotch plaid." The thickly layered strokes of paint convey the rush of the wind, the swaying of the trees and the grain, and the extreme heat of the afternoon. The sense of immediacy is striking; in fact, like Monet (p. 81), Van Gogh painted this landscape on the spot, directly from nature.

The Annenberg Galleries

Pablo Picasso (Spanish, 1881–1973)

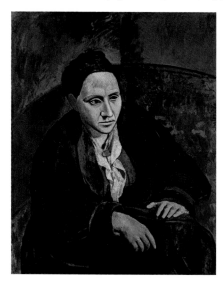

Gertrude Stein, 1905–6

Picasso met the American avant-garde writer Gertrude Stein in Paris after she and her brother acquired several of the young Spaniard's pictures. Soon afterward, Picasso invited Stein to sit for a portrait. She recalled that he required eighty or ninety sittings, but given how quickly Picasso typically painted, the sessions were likely a pretext for socializing. In the spring of 1906, he abandoned the sittings. After a summer vacation in the Spanish Pyrenees, he repainted the face on the portrait. Some groused that it no longer resembled the thirty-two-year-old writer, but as Stein told it, Picasso never wavered: "Yes, he said, everybody says that she does not look like it but that does not make any difference, she will." Stein considered Picasso the greatest artist of her time. She bequeathed the portrait to the Metropolitan in 1946; it was the only work named specifically in her will and the first painting by Picasso to enter the Museum's collection.

Henry J. Heinz II Galleries

Jackson Pollock (American, 1912–1956)

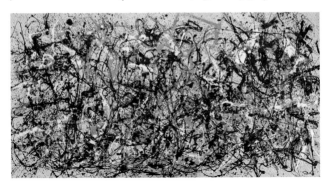

Autumn Rhythm, 1950

Lila Acheson Wallace Wing

To make this large work, Pollock famously laid canvas on the floor and moved all around it, pouring, flicking, spattering, and dripping paint in what may seem to have been a random process but was actually highly controlled. He started with diluted black paint, creating a complex linear skeleton that soaked into the canvas, then wove an intricate web of white, brown, and turquoise over it. The resulting lines have an abstract exuberance—you might think of the swirling clouds in Van Gogh's *Wheat Field with Cypresses* (p. 83). Pollock and other artists working in New York at midcentury, known as the Abstract Expressionists, dramatically altered the trajectory of contemporary art, in subject matter, materials, technique, and scale. Pollock produced *Autumn Rhythm* in 1950, and the Museum acquired it just seven years later. By then, New York had supplanted Paris as the capital of the Western art world.

More works by Pollock and his contemporaries—including pioneers of the Pop Art movement—hang here and in the adjacent galleries.

Chuck Close (American, b. 1940)

Lucas I, 1986–87

2

Lila Acheson Wallace Wing

Chuck Close was a young aspiring artist when he saw a Jackson
Pollock painting for the first time at the Seattle Art Museum. He
was initially disturbed by its abstraction and unorthodox materials,
and then he was inspired. Ironically, in the 1960s he first became
known for paintings that virtually eliminated any trace of the
artist's gesture. Those early monumental portrait heads, based
on photographs, used black, white, and gray to magnify every
facial feature, every pore, to unexpected and unnatural propor-
tions. Later works, such as this portrait of Close's friend and
fellow artist Lucas Samaras, show his development of a more
colorful and painterly style. Here, he moved beyond the hyper-
realism of his earlier portraits to investigate the act of perception,
breaking down visual information into its component parts to
explore the actual process of seeing. He began with a photograph,
drew a grid over it, and methodically reproduced the contents
of each tiny square on a magnified scale on the canvas in dots and
dashes of bright and often contrasting pigments. Viewed up close,
the elements of the picture appear as separate abstract markings;
from a distance, they coalesce into an illusionistic portrait from
which the subject stares intensely out at the viewer.

Blanche and A. L. Levine Court

Visitors' Favorites

A short tour of 12 works of art and spaces especially cherished by museumgoers

PAGES ARE STARRED WITHIN VISITS ONE AND TWO ★

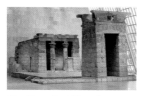

The Temple of Dendur, ca. 15 B.C.
2,000-year-old temple relocated to New York from the banks of the Nile

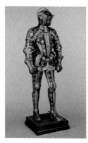

Armor of George Clifford, ca. 1585
Elaborately decorated suit of armor for the Champion of the Queen of England

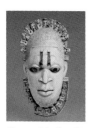

Queen Mother Pendant Mask, 16th century
Masterpiece of ivory carving from Benin, West Africa

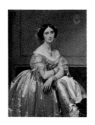

J.-A.-D. Ingres,
Princesse de Broglie, 1851–53
A sumptuous portrait by the French classicist

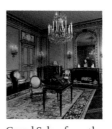

Grand Salon from the Hôtel de Tessé, Paris, 1768–72
One of the Met's lavish French period rooms, containing furniture that belonged to Marie Antoinette

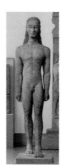

Statue of a Kouros, ca. 590–580 B.C.
Among the earliest marble human figures to be carved in Greece

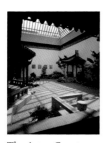

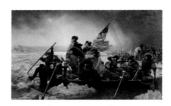

Emanuel Leutze, *Washington Crossing the Delaware*, 1851

Iconic portrayal of a turning point in the American Revolution

The Astor Court

Exquisite garden based on a traditional scholar's court from 17th-century China

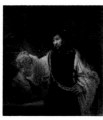

Rembrandt van Rijn, *Aristotle with the Bust of Homer*, 1653

A highlight of the Museum's glorious collection of paintings from the Dutch Golden Age

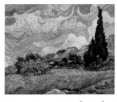

Vincent van Gogh, *Wheat Field with Cypresses*, 1889

Vivid summer landscape by the Post-Impressionist master

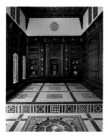

The Damascus Room, 1707

Winter reception room from a private house in Ottoman Syria

Reliefs from the Palace of Ashurnasirpal II, ca. 883–859 B.C.

Monumental guardian figures and reliefs from ancient Iraq during the Assyrian Empire

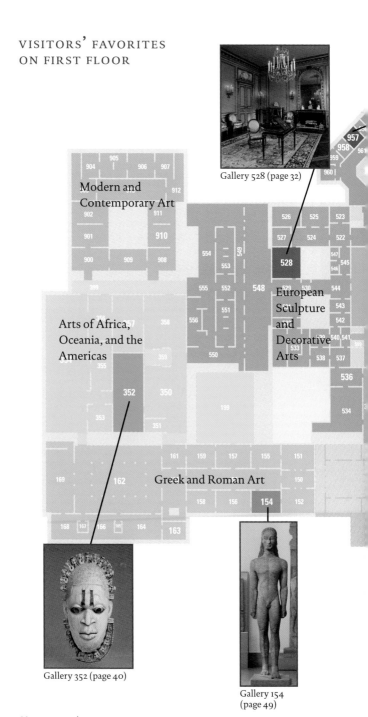

Gallery 528 (page 32)

957
958
959
960
961

Modern and
Contemporary Art

904 905 906 907
912
902 911
901 910
900 909 908

526 525 523
527 524 522
528 547 545
546
544
529 530 543
542
548 540 541
599
533 538 537
536
534

399

Arts of Africa,
Oceania, and the
Americas

554
553
549
555 552
551
556
550
358
359
352 350
355
353 351

European
Sculpture
and
Decorative
Arts

199

161 159 157 155 151
150
162 Greek and Roman Art
158 156 154 152
169
168 167 166 165 164 163

Gallery 352 (page 40)

Gallery 154
(page 49)

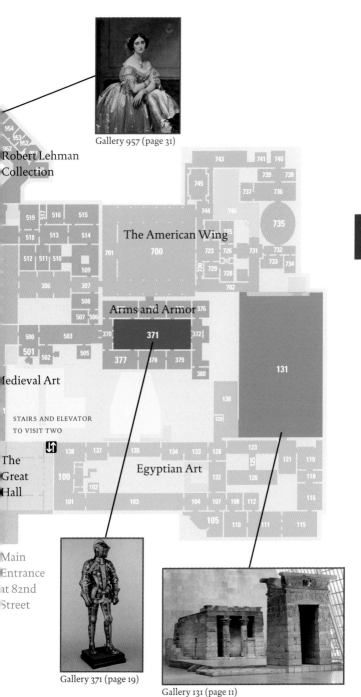

Gallery 957 (page 31)

Robert Lehman
Collection

The American Wing

700

Arms and Armor

371

Medieval Art

STAIRS AND ELEVATOR
TO VISIT TWO

The
Great
Hall

Egyptian Art

100

Main
Entrance
at 82nd
Street

Gallery 371 (page 19)

Gallery 131 (page 11)

VISITORS' FAVORITES
ON SECOND FLOOR

Gallery 637 (page 70)

Gallery 823
(page 83)

924 925

632 631 630 628
633 629

634

636 637 629 European Paintings, 1250–1800

637 629

919

999

918

917

830 826 823 820

828 829 825 822 819

827 824 821 818 800

812 811 810 809

808 807 814 815 817

806

804 803

19th- and Early 20th-Century
European Paintings and Sculpture

852

Art of the Arab Lands, Turkey,
Iran, Central Asia, and Later
South Asia

899

851

850 690

693 691 692

535

454 453 452 175 174 173 406 400

451 176

460 455 456 457 450 405 404 403 402

Ancient Near
Eastern Art

401 203

461 462 463 464

Gallery 461 (page 79)

Gallery 401 (page 75)

Gallery 760 (page 60)

766 | 765 | 764 | 763
768 | 767 | | 762
 | | **760** |
769 | 770 | | 761

609 | 610 | 612
 | 611 | 613
606 | | 614
603 | 604 | 605 | 616 | 615
602 | 624 | | 617
 | 623 | 621 | 618
 | 622 | 620 | 619

706

The American Wing

705

704

684

Musical Instruments

681 | 682

STAIRS AND
ELEVATOR FROM
VISIT ONE

Great Hall
Balcony | 205 | 206 | 233 | 208 | Asian Art

234 | 235 | 236 | 237 | 238 | 239

772 | **771** | 758 | 759
718 | | 755 | 756 | 757
717 | 754 |
722 | 720 | 753 | 752 | 751
721 |
703 | 747 | 748 | 749 | 750

227
228
226 | 229
225 | 230
224 | 231
223 | 232

210 | 212 | 211
209 | **217** | 218 | 213
216 | 215 | 214
241 | 244 | 245 | 246 | 249 | 250
242 | 243 | 247 | 248

Gallery 217 (page 56)

Donor Credits

p. 2
L.1993.88.2 Promised Gift of Florence and Herbert Irving

p. 5
29.100.6 H. O. Havemeyer Collection, Bequest of Mrs. H. O. Havemeyer, 1929

p. 7
20.3.1 Rogers Fund and Edward S. Harkness Gift, 1920

pp. 8–9
13.183.3 Gift of Edward S. Harkness, 1913

p. 10
20.3.12 Rogers Fund and Edward S. Harkness Gift, 1920

pp. 11–13
68.154 Given to the United States by Egypt in 1965, awarded to The Metropolitan Museum of Art in 1967, and installed in The Sackler Wing in 1978

p. 14
52.184 Gift of the Senate House Association, Kingston, N.Y., 1952

pp. 16–17
1978.10.1 Gift of Jeannette Genius McKean and Hugh Ferguson McKean, in memory of Charles Hosmer Morse, 1978

pp. 18–19
32.130.6a–y Munsey Fund, 1932

p. 20
14.100.121a–e Gift of Bashford Dean, 1914

pp. 21–23
39.153 Rogers Fund, 1939

pp. 24–25
17.190.396 Gift of J. Pierpont Morgan, 1917

p. 26
2012.157 Gift of Mrs. Charles Wrightsman, 2012

p. 27
24.167a–k Gift of George D. Pratt, 1924

p. 29
33.23 Rogers Fund, 1933

p. 30
1975.1.148 Robert Lehman Collection, 1975

p. 31
1975.1.186 Robert Lehman Collection, 1975

p. 32
42.203.1 Gift of Mrs. Herbert N. Straus, 1942

pp. 34–35
69.278.1 Alfred Stieglitz Collection, 1969; 59.204.2 Alfred Stieglitz Collection, 1959

p. 36
91.1.1166 Edward C. Moore Collection, Bequest of Edward C. Moore, 1891; 1977.187.22 Bequest of Alice K. Bache, 1977; 69.7.10 Gift of H. L. Bache Foundation, 1969; 1991.419.39 Jan Mitchell and Sons Collection, Gift of Jan Mitchell, 1991

pp. 37–39
2007.96 Purchase, Fred M. and Rita Richman, Noah-Sadie K. Wachtel Foundation Inc., David and Holly Ross, Doreen and Gilbert Bassin Family Foundation and William B. Goldstein Gifts, 2007

p. 40
1978.412.323 The Michael C. Rockefeller Memorial Collection, Gift of Nelson A. Rockefeller, 1972

pp. 44–45
55.11.5 Purchase, Joseph Pulitzer Bequest, 1955

pp. 46–47
03.14.13a–g Rogers Fund, 1903

p. 48
1972.118.95 Bequest of Walter C. Baker, 1971

p. 49
32.11.1 Fletcher Fund, 1932

p. 51
52.81 Rogers Fund, 1952

pp. 52, 55
65.29.4 The Sackler Collections, Purchase, The Sackler Fund, 1965; 65.29.2 Gift of Arthur M. Sackler, in honor of his parents, Isaac and Sophie Sackler, 1965

p. 53
1992.165.19 Charlotte C. and John C. Weber Collection, Gift of Charlotte C. and John C. Weber, 1992

p. 58
L.1993.88.2 Promised Gift of Florence and Herbert Irving

p. 59
26.118 Rogers Fund, 1926

pp. 60–61
97.34 Gift of John Stewart Kennedy, 1897

pp. 62–63
16.53 Arthur Hoppock Hearn Fund, 1916

pp. 64–65
89.4.2929a–e The Crosby Brown Collection of Musical Instruments, 1889

p. 66
52.81 Rogers Fund, 1952

p. 67
14.40.642 Bequest of Benjamin Altman, 1913

p. 68
29.100.6 H. O. Havemeyer Collection, Bequest of Mrs. H. O. Havemeyer, 1929

p. 69
89.15.21 Marquand Collection, Gift of Henry G. Marquand, 1889

pp. 70–71
61.198 Purchase, special contributions and funds given or bequeathed by friends of the Museum, 1961

pp. 72–73
65.183.1 Rogers Fund, 1965

p. 74
32.143.1, .2 Gift of John D. Rockefeller Jr., 1932

p. 75
32.143.6 Gift of John D. Rockefeller Jr., 1932

p. 77
18.17.1, .2 Gift of Samuel T. Peters, 1918; 21.26.12 Rogers Fund, 1921

p. 78
39.20 Harris Brisbane Dick Fund, 1939

p. 79
1970.170 Reception Room (Qa'a) from a Large House, Damascus (Syria), Dated 1119 A.H./A.D. 1707, Gift of The Hagop Kevorkian Fund, 1970

p. 80
89.21.3 Gift of Erwin Davis, 1889; 29.100.53 H. O. Havemeyer Collection, Bequest of Mrs. H. O. Havemeyer, 1929

p. 81
30.95.250 Theodore M. Davis Collection, Bequest of Theodore M. Davis, 1915

pp. 82–83
1993.132 Purchase, The Annenberg Foundation Gift, 1993

pp. 84–85
47.106 Bequest of Gertrude Stein, 1946; © 2013 Estate of Pablo Picasso / Artists Rights Society (ARS), New York

p. 86
57.92 George A. Hearn Fund, 1957; © 2013 The Pollock-Krasner Foundation / Artists Rights Society (ARS), New York

p. 87
1987.282 Purchase, Lila Acheson Wallace Gift and Gift of Arnold and Milly Glimcher, 1987

*The Metropolitan Museum of Art
Director's Tour: A Walking Guide*

Published by The Metropolitan
Museum of Art, New York
In association with
Scala Arts Publishers, Inc.

Mark Polizzotti, Publisher and
 Editor in Chief
Gwen Roginsky, Associate Publisher
 and General Manager of Publications
Peter Antony, Chief Production Manager
Michael Sittenfeld, Managing Editor

Book design by Miko McGinty Inc.
Director of Publications, Scala Arts
 Publishers, Inc., Jennifer Norman
Editor and Project Manager,
 Jennifer Bernstein
Production by Christopher Zichello
Typeset in Documenta

Text, maps, and photography © 2013
The Metropolitan Museum of Art

Compilation and design © 2013
The Metropolitan Museum of Art
and Scala Arts Publishers, Inc.

Cataloging-in-Publication Data is
available from the Library of Congress.
ISBN: 978-1-857579-828-5

Printed in Malaysia
10 9 8 7 6 5 4 3 2 1

Photographs of works in the
Metropolitan Museum's collection
are by The Photograph Studio,
The Metropolitan Museum of Art.

Front cover: Édouard Manet,
*Mademoiselle V … in the Costume of an
Espada* (detail), 1862. H. O. Havemeyer
Collection, Bequest of Mrs. H. O.
Havemeyer, 1929 (29.100.53).
Gallery 810

Back cover: Queen Mother Pendant
Mask, Edo people, Nigeria (Court of
Benin), 16th century. The Michael C.
Rockefeller Memorial Collection,
Gift of Nelson A. Rockefeller, 1972
(1978.412.323). Gallery 352

p. 2: Dancing Celestial, India (Uttar
Pradesh), early 12th century. Promised
Gift of Florence and Herbert Irving
(L.1993.88.2). Gallery 241

p. 5: El Greco, *View of Toledo* (detail),
ca. 1597–99. H. O. Havemeyer
Collection, Bequest of Mrs. H. O.
Havemeyer, 1929 (29.100.6).
Gallery 611

p. 77: Folio from a Qur'an Manuscript,
Samarqand, present-day Uzbekistan,
late 14th–early 15th century. Gift of
Samuel T. Peters, 1918 (18.17.1, .2);
Rogers Fund, 1921 (21.26.12). Gallery 450

The Metropolitan Museum of Art
1000 Fifth Avenue
New York, New York 10028
metmuseum.org

Scala Arts Publishers, Inc.
141 Wooster Street, Suite 4D
New York, NY 10012

Distributed to the booktrade by
Antique Collectors' Club Limited
6 West 18th Street
New York, New York 10011